Follow the Directions
& Draw It
All by Yourself!

by Kristin Geller

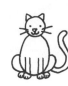 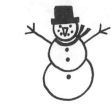 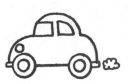

SCHOLASTIC
PROFESSIONAL **B**OOKS

NEW YORK • TORONTO • LONDON • AUCKLAND • SYDNEY
MEXICO CITY • NEW DELHI • HONG KONG

For Hannah and Sarah, my future artists!
For all the students at Hawthorne Elementary School.

"Ladybugs" by Valerie Schiffer. Copyright Valerie Schiffer. Used by permission of the author.

"A Dinosaur at the Door" by Helen H. Moore. Copyright © 1997 by Helen H. Moore. Used by permission of the author.

Cover design by George Myer
Interior design by Solutions by Design, Inc.
Interior illustrations by James Graham Hale

ISBN: 0-439-14007-2

Contents

Introduction

Within every child is an artist. Although children are intrinsically creative, they need guidance to nurture their artistic talent. Many young children have difficulty with art because their fine-motor skills are still developing. This can lead to frustration when the results do not meet the artists' expectations. Children also may feel frustrated when they want to draw something that does not fall within their comfort range of simple, familiar subjects. The easy step-by-step drawing lessons in this book are designed to help children draw a wide range of subjects—from teddy bears to birthday cakes—and help them gain confidence in their artistic abilities. The drawing lessons also help children:

☺ learn to follow visual and written directions.

☺ build fine-motor skills.

☺ strengthen hand-eye coordination.

☺ develop far-point and near-point copying skills.

☺ learn basic shapes.

☺ expand knowledge of art concepts.

Each of the 28 drawing lessons in this book includes both student and teacher pages. The reproducible student pages include illustrated step-by-step directions for drawing a cat, a kite, a dinosaur, and so on. The teacher pages provide written instructions in simple language that is easy for children to understand. The teacher may read the directions aloud or write them on chart paper, on the chalkboard, or on sentence strips to be placed in a pocket chart. In addition, the teacher pages include suggested thematic links that connect the drawing lessons to broader units of study, as well as book links, extension activities, and teacher tips.

Naturally, "cookie cutter" art is not the final goal. The lessons in this book are designed to expand children's artistic horizons and to bolster their confidence as artists. The drawing lessons can also serve as the basis for many rich learning experiences that involve not only art but also math, science, and language arts.

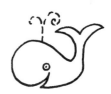

Follow the Directions and Draw It All by Yourself! Scholastic Professional Books

How to Use This Book

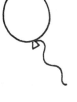

This book was designed for utmost flexibility and learning mileage. The drawing lessons are arranged in order of difficulty, starting with very simple three-step drawings and moving through six- and eight-step drawings. You can use the lessons in any order to meet the needs of your students and curriculum; however, to introduce children to the concept of following visual and written directions, I suggest starting with the simpler lessons.

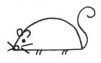

The drawing lessons can be used in a variety of ways: Children can do them independently in a learning center, in small groups, or as a whole class. It is a good idea to guide students through a few lessons first, either in small groups or as a class. To reinforce reading skills, display the written directions. You may choose to write the directions on the chalkboard, on chart paper, or on sentence strips for a pocket chart. You might also write them on a sheet of paper to reproduce for students. However you choose to provide the written directions, be sure to read them aloud with students, stressing the connection between the written and visual directions. For younger students, emphasize one-to-one word correspondence. As you read each step aloud, draw the step on the chalkboard or on chart paper. Be sure to draw large enough so that everyone can see. First, draw all of the steps while students observe, and then draw the steps again while students draw.

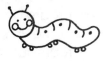

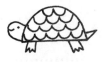

The drawing lessons also highlight important math concepts such as numbers and shapes. Emphasize these concepts as you review the steps with students. For example, a step might involve drawing two circles or three squares. As a warm-up exercise for a drawing lesson, review basic shapes with children. (See Basic Shapes and Doodles on page 7.) Allow children to explore shapes tactilely whenever possible, creating patterns with blocks or cutouts of various shapes. As you review the directions, also emphasize spatial concepts such as top, bottom, center, middle, left, right, small, medium, and large.

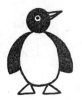

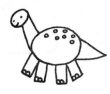

To find drawing lessons that tie in to your curriculum, see the Table of Contents on page 3 or review the Theme Links on each teacher page. Many of the lessons connect with units on seasons, holidays, or animals. The Book Links sections suggest literature that can be used to introduce or follow up the drawing lessons. Extension Activities incorporate the drawing lesson into other curriculum areas, such as reading, writing, science, and math. You'll also find ideas for creatively displaying finished pieces of art. Use the template on page 64 to create additional drawing lessons for students (or have children create their own to share with their classmates).

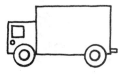

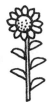

When children first learn to draw a particular subject, use basic art supplies (such as pencil and crayon) and simple techniques. After children have had opportunities to draw a subject a few times, allow them to explore new art media—for example, markers, colored pencils, oil pastels, and paint. Gradually introduce new techniques, such as outlining, shading, and blending colors. Encourage children to fill the drawing space on the reproducible sheets.

Once children feel comfortable with the step-by-step directions, encourage them to work independently. In an art center, set out reproducible drawing pages and written directions, along with the necessary supplies. Or place the drawing pages, directions, and supplies in a writing center to encourage students to illustrate their writing. For at-home use, create an art backpack that children can take turns bringing home. In the backpack, store basic art supplies and reproducible drawing lessons. Collect samples of students' artwork throughout the year, bind them together in a mini-book, and attach the reproducible cover below. Use this book to display children's artistic development throughout the year.

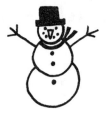
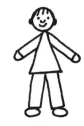
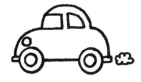

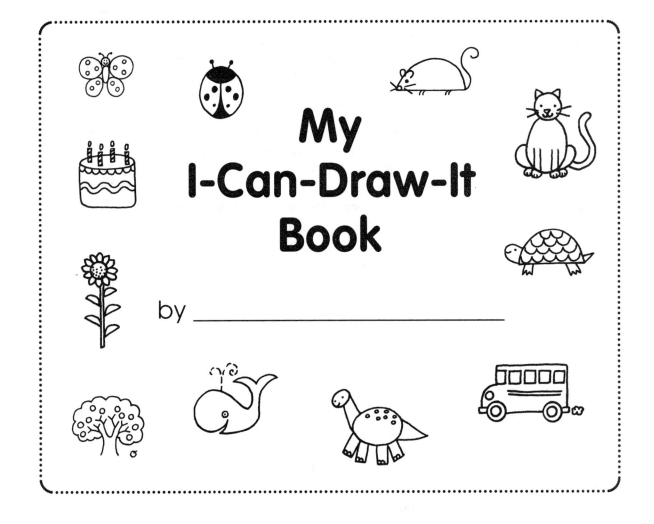

My I-Can-Draw-It Book

by _____

Basic Shapes and Doodles

The following shapes are used throughout the drawing lessons in this book. Review these shapes with students so that they recognize both the shape and its written name.

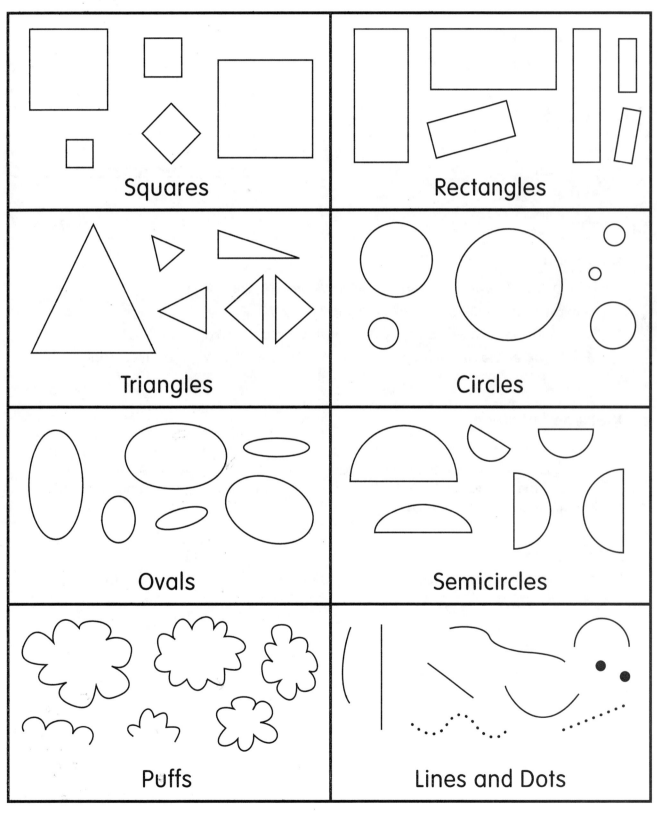

Squares

Rectangles

Triangles

Circles

Ovals

Semicircles

Puffs

Lines and Dots

You Can Draw an Apple!

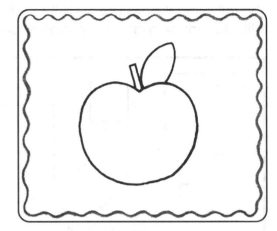

Directions

1. Draw a circle with two bumps on top.
2. Draw a rectangle for the stem.
3. Draw a pointed leaf.

Theme Links

☺ Harvest
☺ Autumn
☺ Fruit
☺ Nutrition

Book Links

How Do Apples Grow? by Betsy Maestro (HarperCollins, 1992)

I Am an Apple by Jean Marzollo (Scholastic, 1997)

Picking Apples and Pumpkins by Amy and Richard Hutchings (Scholastic, 1994)

What's So Terrible About Swallowing an Apple Seed? by Lerner and Goldhar (HarperCollins, 1996)

Extension Activity

Bring a variety of apples to school (Granny Smith, golden delicious, Macintosh, and so on), and hold an apple tasting for students. Cut up the apples into small pieces, keeping them together by type. Then have students taste each kind and pick their favorite. Graph the results as a group math activity.

TEACHER TIP

Have students draw ten apples in a row. Challenge them to create a pattern by coloring the apples with red, green, and yellow crayons.

You Can Draw an Apple!

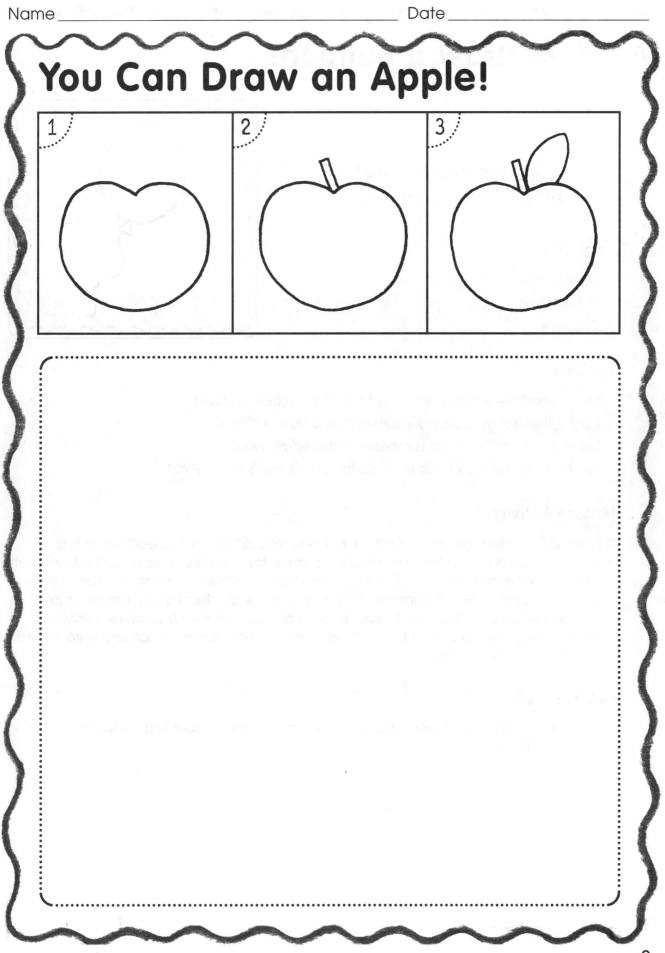

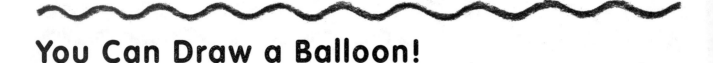

You Can Draw a Balloon!

Directions

1. Draw an oval.
2. Draw a small triangle on the bottom.
3. Add a curved line for the string.

Theme Links

☺ Celebrations
☺ Birthdays
☺ Circus

Book Links

Louella and the Yellow Balloon by Molly Coxe (Crowell, 1988)

Mine's the Best by Crosby Bonsall (Harper & Row, 1973)

The Red Balloon by Albert Lamorisse (Doubleday, 1956)

Too Many Balloons by Catherine Matthias (Children's Press, 1982)

Extension Activity

Invite children to draw, color, and cut out several balloons so that each child has at least ten balloons. (If children work with a partner for this activity, each pair will need at least ten balloons.) Have each child or each pair of children write an addition sign (+) and an equal sign (=) on small pieces of paper. Show children how to create simple addition equations using their balloons—such as *3 balloons + 2 balloons = 5 balloons*. After forming several different equations, have children glue their balloons onto a sheet of paper to show one equation.

TEACHER TIP

Use cut-out balloons (or real balloons) to teach children concepts of a dozen and half-dozen.

Name _____ Date _____

You Can Draw a Balloon!

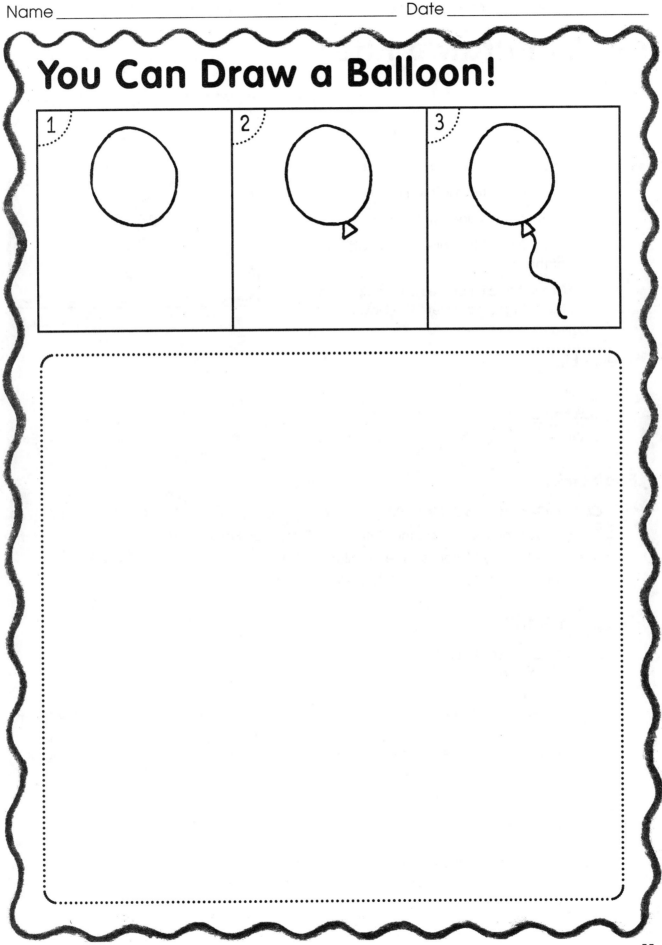

Follow the Directions and Draw It All by Yourself! Scholastic Professional Books

You Can Draw a Kite!

Directions

1. Draw a diamond.
2. Draw a line from the top to the bottom.
3. Draw a line from left to right.
4. Draw a curvy line for the string.
5. Draw 2 small triangles on the left side of the string.
6. Draw 2 small triangles on the right side of the string to complete the bows.

Theme Links

☺ Spring
☺ Weather
☺ Wind

Book Links

Curious George Flies a Kite by Margaret Rey (Houghton Mifflin, 1958)

The Big Kite Contest by Dorotha Ruthstrom (Pantheon Books, 1980)

The Funny Ride by Margaret Hillert (Follett, 1982)

The Wind Blew by Pat Hutchins (Macmillan, 1974)

Extension Activity

Read aloud to students the following poem:

> **A Kite**
> I often sit and wish that I
> Could be a kite up in the sky,
> And ride upon the breeze and go
> Whichever way I chanced to blow.
> —Anonymous

Ask children if there is anything they have ever wished to be: A bird? A boat? A hot air balloon? Ask them to imagine what it would be like to be this thing or creature, and invite them to write or dictate a poem or description.

TEACHER TIP

Have students color and cut out their kites. Then show them how to attach a piece of yarn to the back of their kites with tape. Display the kites on a bulletin board covered with light blue craft paper and dotted with cotton-ball clouds.

You Can Draw a Kite!

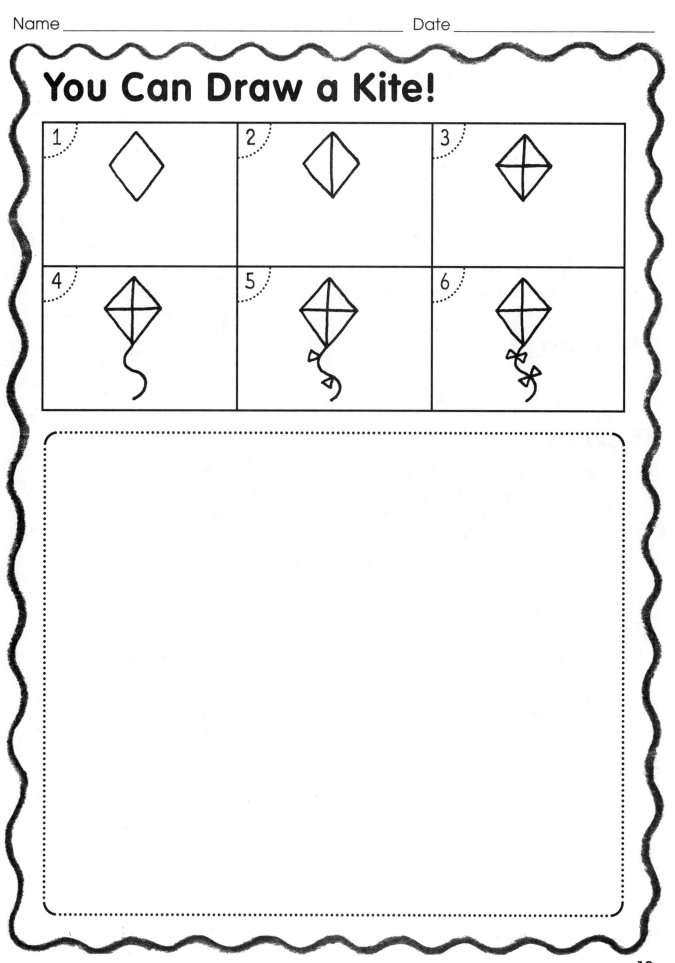

You Can Draw a Mouse!

Directions

1. Draw a semicircle for the body.
2. Draw 2 curved lines for the ears.
3. Draw a small circle for an eye.
4. Draw a small circle for the nose.
5. Draw lines for whiskers and feet.
6. Draw a curved line for the tail.

Theme Links

☺ Animals
☺ Friendship (see Book Links)

Book Links

Alexander the Wind-Up Mouse by Leo Lionni (Pantheon, 1969)

Angelina Ballerina by Katharine Holabird (Crown, 1983)

Doctor De Soto by William Steig (Farrar, Straus & Giroux, 1982)

Do You Want to Be My Friend? by Eric Carle (Crowell, 1971)

If You Give a Mouse a Cookie by Laura Joffe Numeroff (Harper & Row, 1985)

Mouse Paint by Ellen Stoll Walsh (Harcourt Brace Jovanovich, 1989)

Extension Activity

To prepare for this activity, draw three mice on a sheet of paper. Make a copy of the page for each student. After reading *Mouse Paint*, give each student a copy of the page and a small amount of tempera paints in primary colors (red, blue, and yellow). Guide students as they mix their paints and then paint each mouse a different color: green (yellow and blue), orange (red and yellow), and purple (blue and red).

TEACHER TIP

Encourage children to rinse their brushes before dipping them into each new color.

You Can Draw a Mouse!

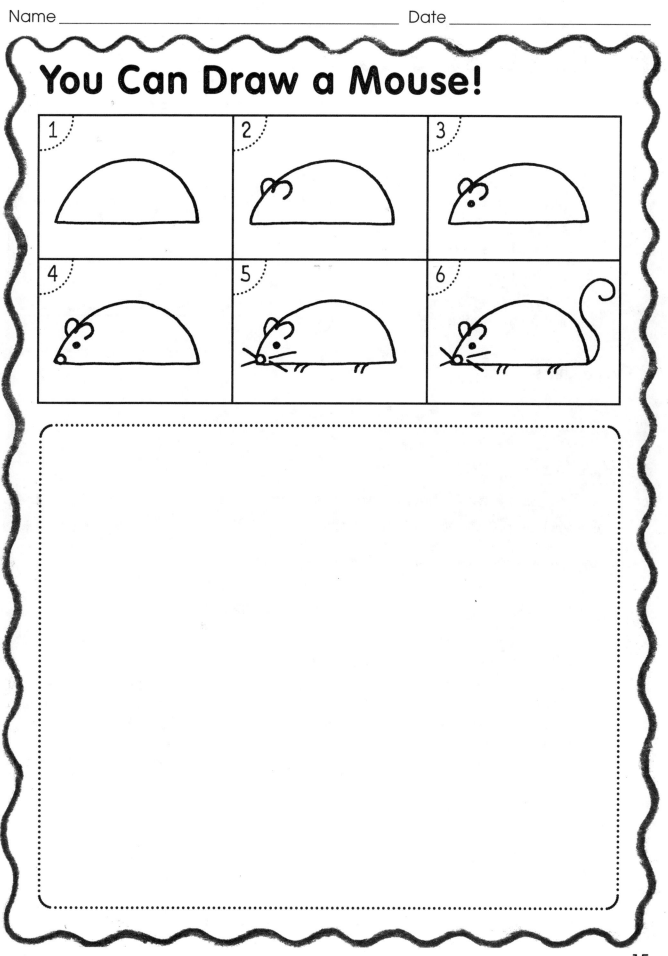

You Can Draw a Spider!

Directions

1. Draw a circle for the body.
2. Draw a smaller circle inside for the head.
3. Starting at the head, draw 2 bent lines for the legs.
4. Draw 2 more bent lines.
5. Draw 4 more bent lines.
6. Add eyes and a mouth. Add a dashed line for the silk thread.

Theme Links

☺ Insects

☺ Halloween

Book Links

Amazing Spiders by Alexandra Parsons (Knopf, 1990)

Anansi the Spider: A Tale From the Ashanti by Gerald McDermott (Holt, Rinehart and Winston, 1972)

Miss Spider's Tea Party by David Kirk (Scholatic, 1994)

The Spider Who Created the World by Amy MacDonald (Orchard Books, 1996)

The Very Busy Spider by Eric Carle (Philomel Books, 1984)

Extension Activity

In *The Itsy Bitsy Spider* (Whispering Coyote Press, 1993), author Iza Trapani has added on to the well-known song. First review the movements that go along with the song "The Itsy Bitsy Spider." Then read the book aloud, and invite children to think of movements for the spider's new adventures.

— From *Spiders*, a complete cross-curricular theme unit, by Rhonda Lucas Donald and Kathleen W. Kranking (Scholastic Professional Books, 1999)

TEACHER TIP

For a dramatic effect, have children draw spiders with white or yellow chalk on black paper.

You Can Draw a Spider!

You Can Draw an Inchworm!

Directions

1. Draw a circle for the head.
2. Draw a curvy line for the top of the body.
3. Draw another curvy line for the bottom of the body.
4. Add pairs of small circles for feet.
5. Add lines and dots for antennae, stripes, and spots.
6. Add facial features.

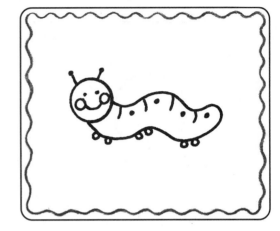

Theme Links

☺ Insects
☺ Spring
☺ Summer
☺ Measurement
☺ Author Study of Leo Lionni

Book Links

Bugs by Nancy Winslow Parker and Joan Richards Wright (Greenwillow Books, 1987)

Flit! Flutter! Fly! poems selected by Lee Bennett Hopkins (Doubleday, 1992)

Inch by Inch by Leo Lionni (I. Obolensky, 1960)

Extension Activity

Cut strips of paper in three different lengths: 3 inches, 6 inches, and 12 inches. You will need three strips for each student (one of each length). Invite children to draw three inchworms—one on each strip—following the directions above and on page 19. Encourage children to make their inchworms as long as the strips. Kids can then use their inchworms for measuring fun!

TEACHER TIP

After kids have finished drawing their inchworms in the above extension activity, have them use rulers to measure each inchworm. Then have them label each inchworm with its measurement (3 inches, 6 inches, or 12 inches).

You Can Draw an Inchworm!

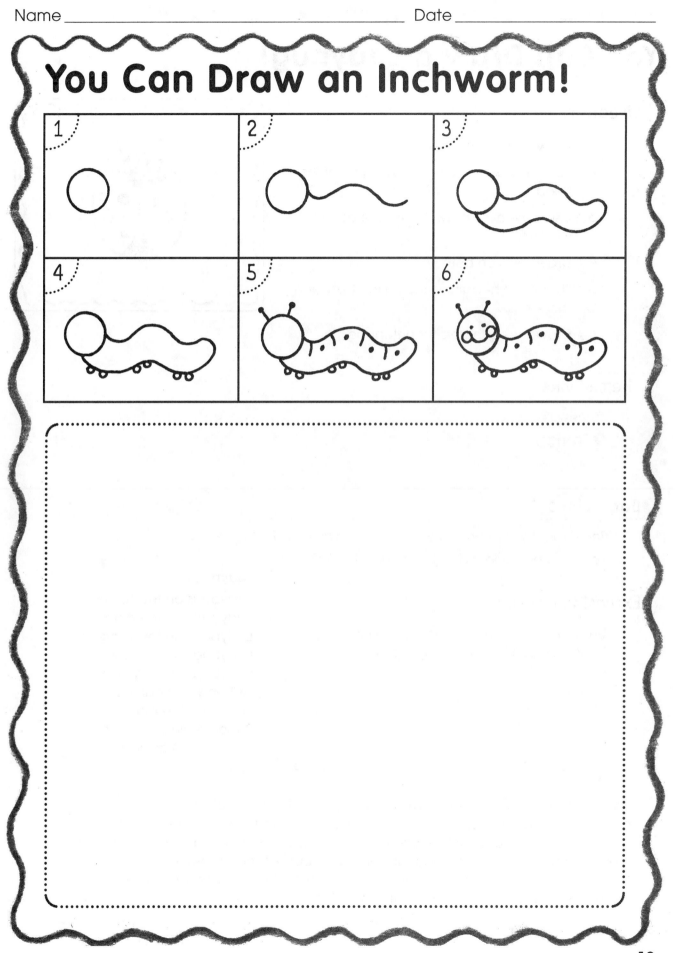

You Can Draw a Ladybug!

Directions

1. Draw an oval for the body.
2. Inside the oval, draw a curved line for the head.
3. Inside the oval, draw 2 curved lines for the wings.
4. Draw spots on both wings.
5. Shade the head and the space between the wings.
6. Draw lines with dots for antennae.

Theme Links

- ☺ Insects
- ☺ Spring
- ☺ Summer

Book Links

The Grouchy Ladybug by Eric Carle (Crowell, 1977)
Ladybug by Barrie Watts (Silver Burdett, 1987)

Extension Activity

Use the pocket chart poem "Ladybugs" by Valerie Schiffer for a language arts lesson.

Ladybugs

Ladybugs on the flowers.
Ladybugs on the corn.
Ladybugs on the leaves.
Ladybugs on the lawn.
Ladybugs in my garden
As hungry as can be
Eating up the aphids
So something's left for me.
—Valerie Schiffer

TEACHER TIP

Invite children to draw large ladybugs on $8\frac{1}{2}$- by 11-inch sheets of white construction paper. Then have them paint the ladybugs with red and black paint. When the paint has dried, kids can cut out the ladybugs. To make a ladybug pillow, they can trace their ladybug onto another sheet of paper and cut out the shape. Staple these shapes together, leaving an opening to stuff the pillow with shredded newspaper. When you are done stuffing the pillow, staple the opening.

You Can Draw a Ladybug!

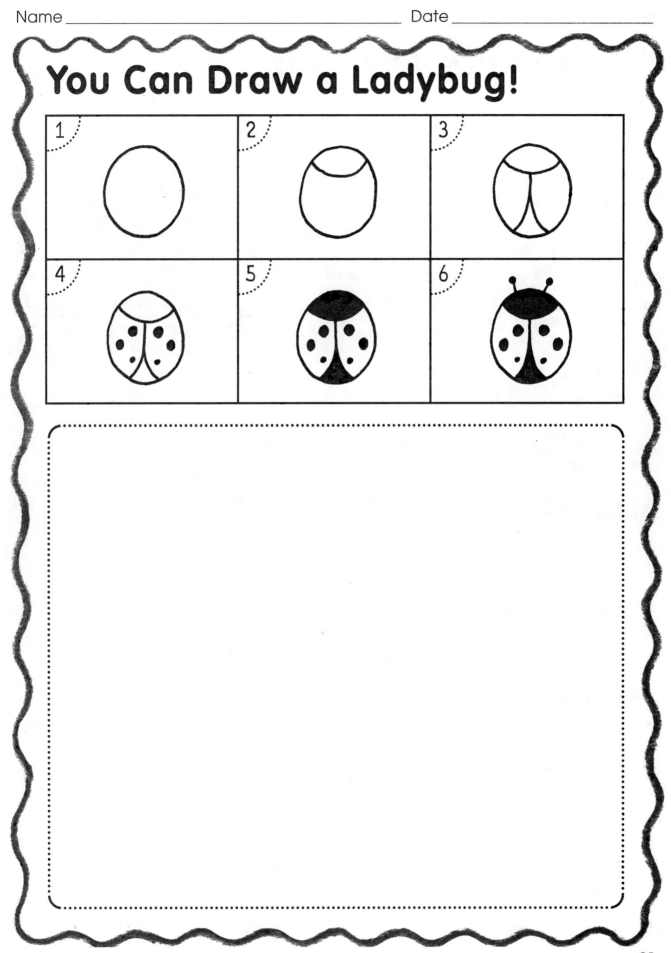

You Can Draw a Butterfly!

Directions

1. Draw a small circle for the head.
2. Draw a long oval for the body.
3. Draw 2 large circles for the top of the wings.
4. Draw 2 medium circles for the bottom of the wings.
5. Draw 2 curves with dots for the antennae.
6. Add details on the wings and facial features.

Theme Links

☺ Insects
☺ Spring
☺ Summer
☺ Life Cycles

Book Links

Discovering Butterflies by Douglas Florian (Macmillan, 1986)

An Invitation to the Butterfly Ball by Jane Yolen (Philomel Books, 1976)

The Life of a Butterfly (Super Science Readers) by Robin Bernard (Scholastic Professional Books, 2000)

Look... A Butterfly by David Cutts (Troll, 1982)

The Very Hungry Caterpillar by Eric Carle (Collins Publishers, 1979)

Extension Activity

Make a class mural depicting the life cycle of a butterfly, from egg to caterpillar to chrysalis to butterfly. Invite kids to draw, color, and cut out large butterflies to add to the mural. Before gluing the butterflies onto the mural, have students fold the butterfly in half and open it. This will create a three-dimensional effect for the wings.

TEACHER TIP

Use the butterfly drawing activity to introduce or reinforce the concept of symmetry. On chart paper or on the chalkboard, model the drawing directions above. Stress spatial concepts as you draw (top, bottom, left, right, and center). Discuss the concept of symmetry as you draw and again as you color a symmetrical pattern on the wings.

You Can Draw a Butterfly!

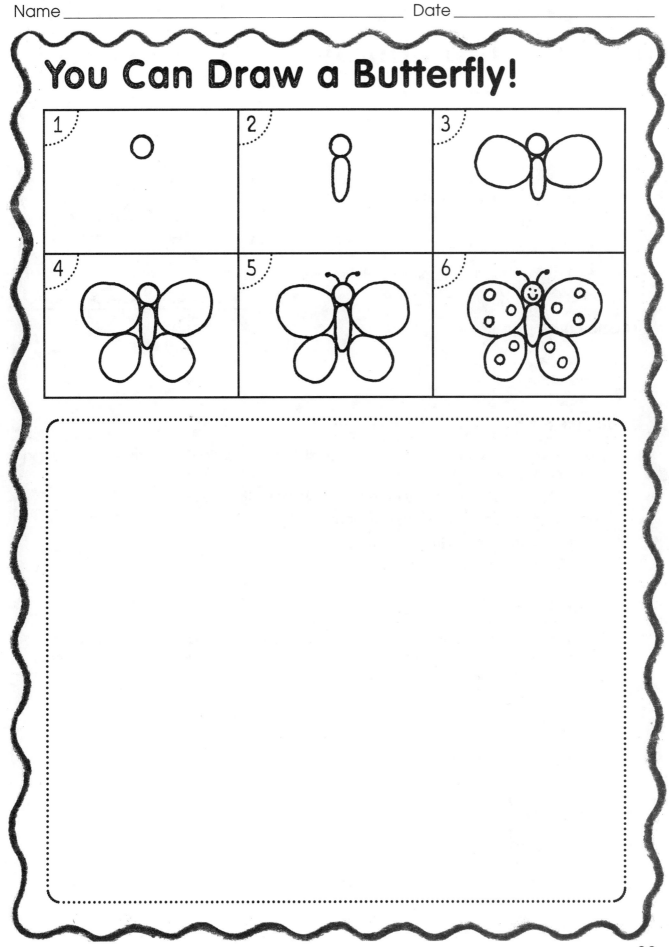

You Can Draw a Turtle!

Directions

1. Draw a semicircle for the turtle's shell.
2. Draw a small semicircle for the head.
3. Draw a small triangle for the tail.
4. Draw pointed shapes for the feet.
5. Add facial features.
6. Draw curved lines to give the shell texture.

Theme Links

☺ Reptiles
☺ Pond Life

Book Links

Franklin Goes to School by Paulette Bourgeois (Scholastic, 1995) and other books in the Franklin series

In the Middle of the Puddle by Mike Thaler (Harper & Row, 1988)

Sea Turtles by Gail Gibbons (Holiday House, 1995)

Thomas the Tortoise by Graham Jeffery (Crown, 1988)

Turtle Tale by Frank Asch (Dial, 1978)

Extension Activity

After exploring books about turtles, invite students to write or dictate poems about turtles. For inspiration, they can look at photographs or illustrations. If desired, have children use the following outline for their poem:

	For example:
Size and texture of turtle	Small, hard, and smooth
Color of turtle	Green and brown
Location of habitat	Lives in a pond
Closing line	My turtle!

TEACHER TIP

Invite students to illustrate their poems following the directions above and on page 25. After drawing in pencil, students can outline their turtle using green paint. When the paint has dried, children can color their turtle with green, brown, and yellow crayons.

You Can Draw a Turtle!

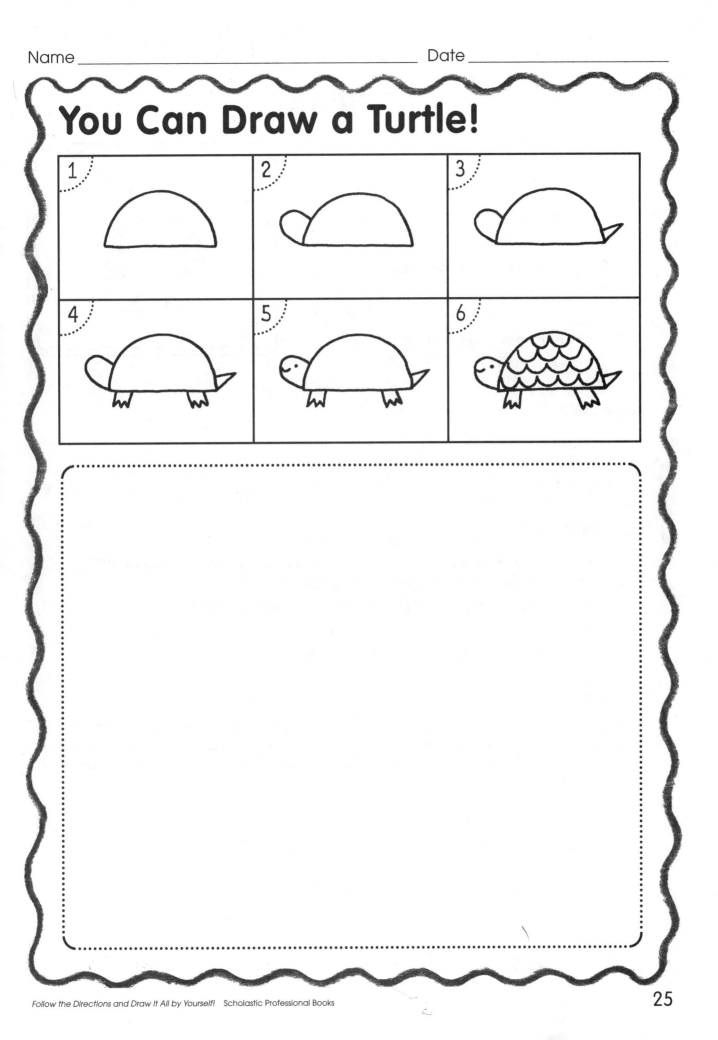

You Can Draw a Penguin!

Directions

1. Draw a small circle for the head.
2. Draw a large oval for the body.
3. Draw 2 pointed shapes for wings.
4. Draw 2 triangles for the flippers.
5. For the beak, draw a triangle with a line through it. Draw a circle for the eye.
6. Shade the head and wings, and add a dot for the eyeball.

Theme Links

- ☺ Penguins
- ☺ Winter
- ☺ Arctic Life

Book Links

Antarctic Antics: A Book of Penguin Poems by Judy Sierra (Harcourt Brace, 1998)

Cuddly Dudley by Jez Alborough (Candlewick Press, 1993)

The Penguin by Paula Z. Hogan (Raintree Children's Books, 1979)

Penguins by Rene Mettler (Scholastic, 1996)

Tacky the Penguin by Helen Lester (Houghton Mifflin, 1988)

Extension Activity

Make a collaborative reference book about penguins! Have each student draw a penguin picture. Then read aloud several books about penguins. Ask students to write or dictate three facts about penguins. They can then illustrate their fact page and add it to the book.

TEACHER TIP

Display the collaborative penguin book in a science learning center. Make other reference books throughout the year as your class studies other animals (such as butterflies, turtles, frogs, and others included in this book).

Name _____ Date _____

You Can Draw a Penguin!

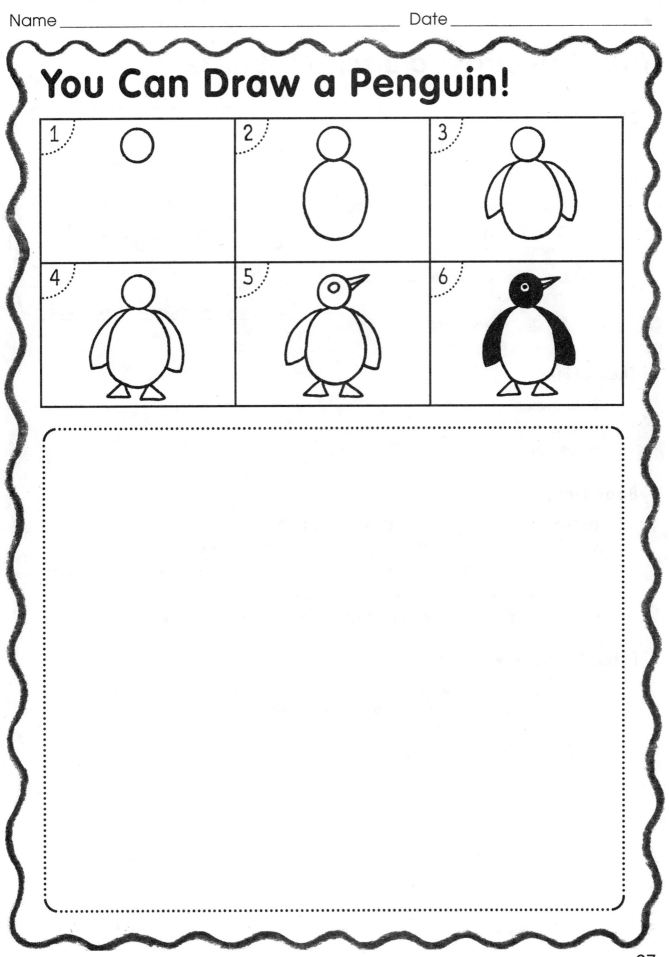

You Can Draw a Jack-O'-Lantern!

Directions

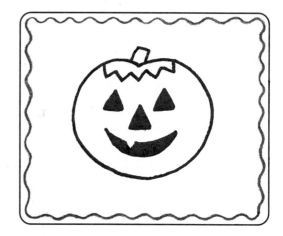

1. Draw a circle with 2 bumps on top.
2. Draw a small square for the stem.
3. Draw a zigzag line across the top.
4. Draw 2 small triangles for eyes and 1 for a nose.
5. Draw a curved shape with a point for the mouth.
6. Shade the eyes, nose, and mouth.

Theme Links

☺ Halloween
☺ Harvest
☺ Autumn

Book Links

Big Pumpkin by Erica Silverman (Macmillan, 1992)

Jeb Scarecrow's Pumpkin Patch by Jana Dillon (Houghton Mifflin, 1992)

The Little Old Lady Who Was Not Afraid of Anything by Linda Williams (Crowell, 1986)

The Pumpkin Man by Judith Moffatt (Scholastic, 1998)

Pumpkin Pumpkin by Jeanne Titherington (Greenwillow Books, 1986)

Extension Activity

Discuss various emotions and the facial expressions that show each one (kids enjoy demonstrating the expressions). Then ask children to draw a series of jack-o'-lanterns with various expressions: happy, sad, scary, surprised, and so on. Have a class vote to determine the favorite face, and then carve a real pumpkin to match!

TEACHER TIP

Give each student a 12- by 18-inch sheet of drawing paper. After children draw their pumpkins in pencil, have them outline their drawing with a thin paintbrush and black paint. Once the paint has dried, kids can color their pumpkins with crayons or markers. Then have them cut out the pumpkins and mount them on black paper.

Name _____ Date _____

You Can Draw a Jack-O'-Lantern!

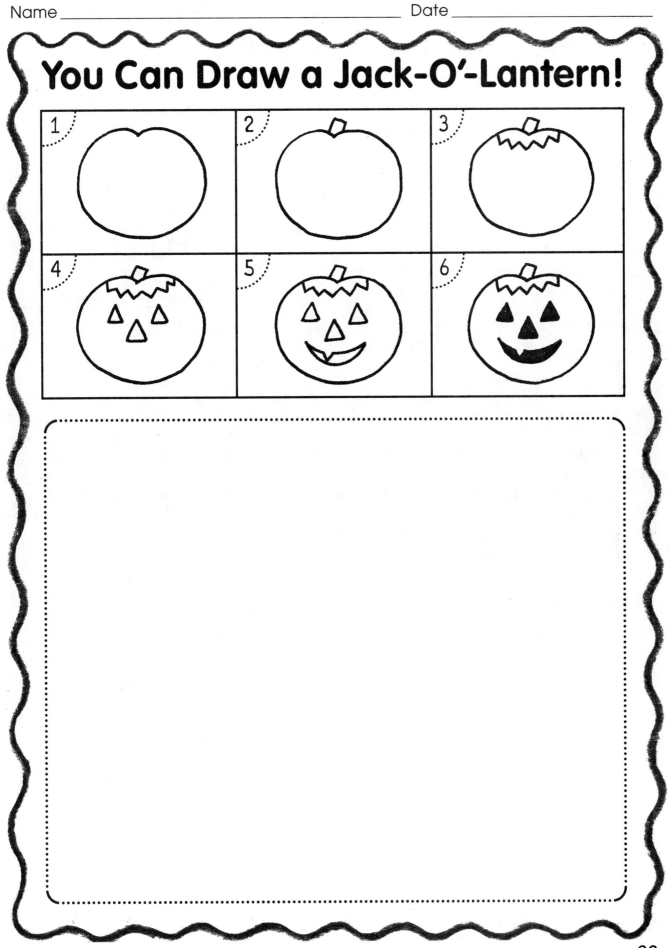

You Can Draw a Dinosaur!

Directions

1. Draw a small oval for the head.
2. Draw a large oval for the body.
3. Connect the head and body with two lines.
4. Draw a curved triangle for the tail.
5. Draw four rectangles for legs.
6. Add facial features, spots, and toes.

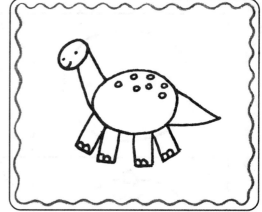

Theme Links

☺ Dinosaurs

☺ Bones and Fossils

Book Links

Dinosaur Bob and His Adventures With the Family Lazardo by William Joyce (Harper & Row, 1988)

Dinosaurs by Liza Charlesworth and Bonnie Sachatello-Sawyer (Scholastic Professional Books, 1996)

Dinosaurs, Dinosaurs by Byron Barton (Crowell, 1989)

If the Dinosaurs Came Back by Bernard Most (Harcourt Brace Jovanovich, 1978)

Extension Activity

Read aloud to children the delightful poem "A Dinosaur at the Door." Then ask kids to imagine what they would do if a dinosaur knocked on *their* door!

A Dinosaur at the Door

Would you open your door
To a Dinosaur?
Would you open it wide and say, "Hi"?
Would you welcome him in?
Would you say with a grin,
"I'm so terribly glad you came by"?

If you did, you might find
That it pays to be kind,
For a dinosaur makes a great pet.
They're big, and they're fun,

They go "thump" when they run,
And they don't mind if you
Get them wet!
So open your door
To a big dinosaur,
And welcome him into your home.
Give your parents a shock,
Be the first on your block
With a home where the dinosaurs roam!
—Helen H. Moore

You Can Draw a Dinosaur!

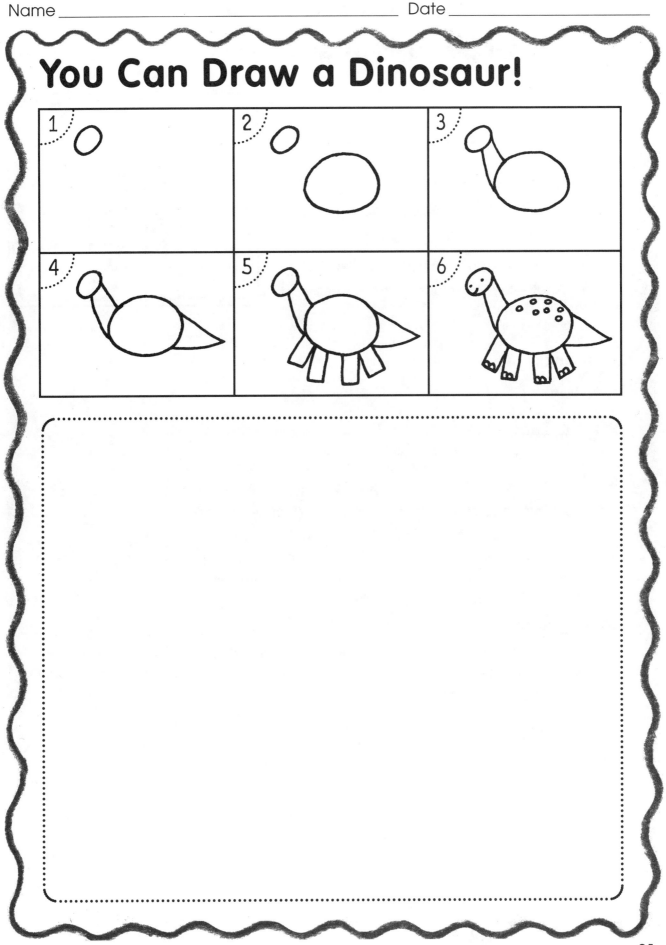

You Can Draw a House!

Directions

1. Draw a large square or rectangle for the house.
2. Draw a triangle for the roof.
3. Draw a small rectangle for the chimney.
4. Draw a small rectangle for the door.
5. Draw small rectangles for windows.
6. Add details like shrubs, windowpanes, and a doorknob.

Theme Links

- All About Me
- Families
- Community

Book Links

The Biggest House in the World by Leo Lionni (Pantheon, 1968)

Building a House by Byron Barton (Greenwillow Books, 1981)

A House Is a House for Me by Mary Ann Hoberman (Viking Press, 1978)

The House That Jack Built by Mother Goose (Holiday House, 1985)

Extension Activity

Read aloud *The Big Orange Splot* by Daniel Pinkwater (Hastings, 1977). Distribute art supplies and invite children to draw their imaginary dream homes. The more colorful and creative, the better!

TEACHER TIP

Make a collaborative class map of an imaginary town. Cover a bulletin board with a large sheet of craft paper. Have children draw and label streets, rivers, ponds, mountains, and so on. They can decide where on the map to attach their drawings of houses. Decide together on names for the town, streets, and so on. This is a great springboard for learning about directions, addresses, and maps.

Name _____ Date _____

You Can Draw a House!

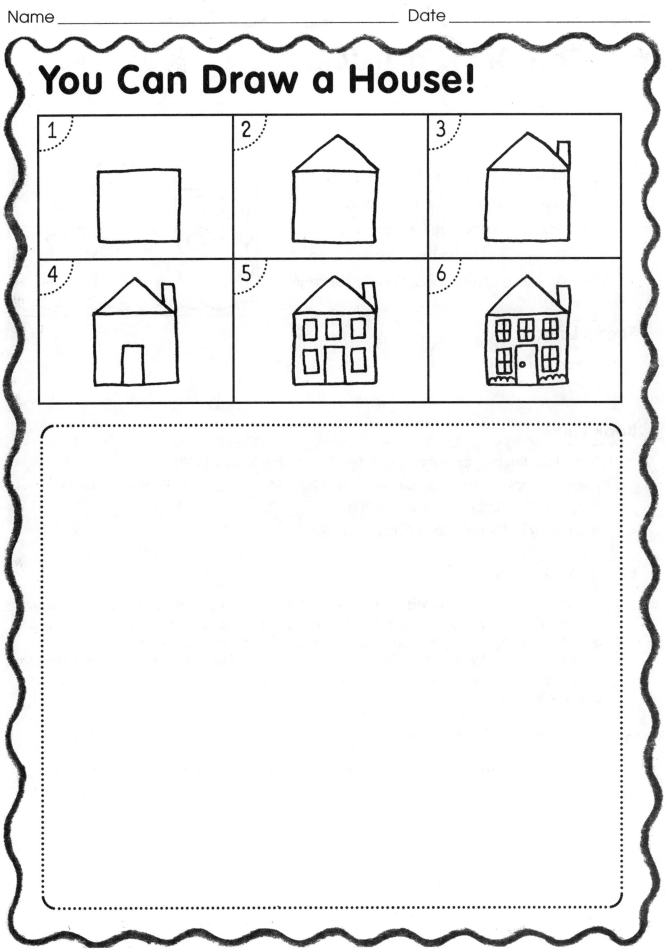

You Can Draw a Truck!

Directions

1. Draw 2 circles for the wheels.
2. Draw a rectangle for the truck body.
3. Draw a rectangle for the truck cab.
4. Draw a small square for the window.
5. Draw a small rectangle for the tailpipe.
6. Draw circles for hubcaps and a headlight.

Theme Links

☺ Transportation
☺ Wheels

Book Links

Sam Goes Trucking by Henry Horenstein (Houghton Mifflin, 1989)
Traffic: A Book of Opposites by Betsy and Giulio Maestro (Crown Publishers, 1981)
Trucks by Gail Gibbons (Crowell, 1981)
Truck Song by Diane Siebert (Crowell, 1984)

Extension Activity

Create a class graph entitled "Our Favorite Ways to Travel." First, ask children to draw a picture of their favorite way to travel (boat, airplane, car, rocket, hot air balloon, and so on). Draw a large bar graph on chart paper, and add each of the means of transportation children illustrated. Then invite children one by one to shade in a square on the graph that shows their favorite way to travel. Have them count the results and post the winner.

TEACHER TIP

Invite children to write or dictate a short story about a trip they have taken (imaginary or real).

You Can Draw a Truck!

1	2	3
4	5	6

You Can Draw a Birthday Cake!

Directions

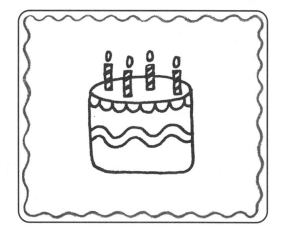

1. Draw a square that does not have a top line.
2. Draw an oval for the top of the cake.
3. Draw 2 curvy lines for the icing.
4. Draw small semicircles along the top of the cake for icing.
5. Draw rectangles on top for candles.
6. Draw stripes on the candles and add small ovals for flames.

Theme Links

☺ Birthdays
☺ All About Me
☺ Calendar Skills

Book Links

Happy Birthday to You by Dr. Seuss (Random House, 1959)

Happy Birthday, Moon by Frank Asch (Prentice, 1982)

The Secret Birthday Message by Eric Carle (Crowell, 1972)

Extension Activity

Have students work in teams to create 12 birthday cakes. Label one cake for each month. Give each student a paper candle, and have each student write their name on their candle. Then invite children to place their candle on the month in which they were born. Tally the results.

TEACHER TIP

For the above extension activity, use large pieces of sturdy, colored construction paper. Model the step-by-step drawing at an easel so that students can follow along. After you have labeled each cake with a month, challenge students to arrange the months in chronological order. Or have kids arrange them first in alphabetical order and then in chronological order.

Name _____ Date _____

You Can Draw a Birthday Cake!

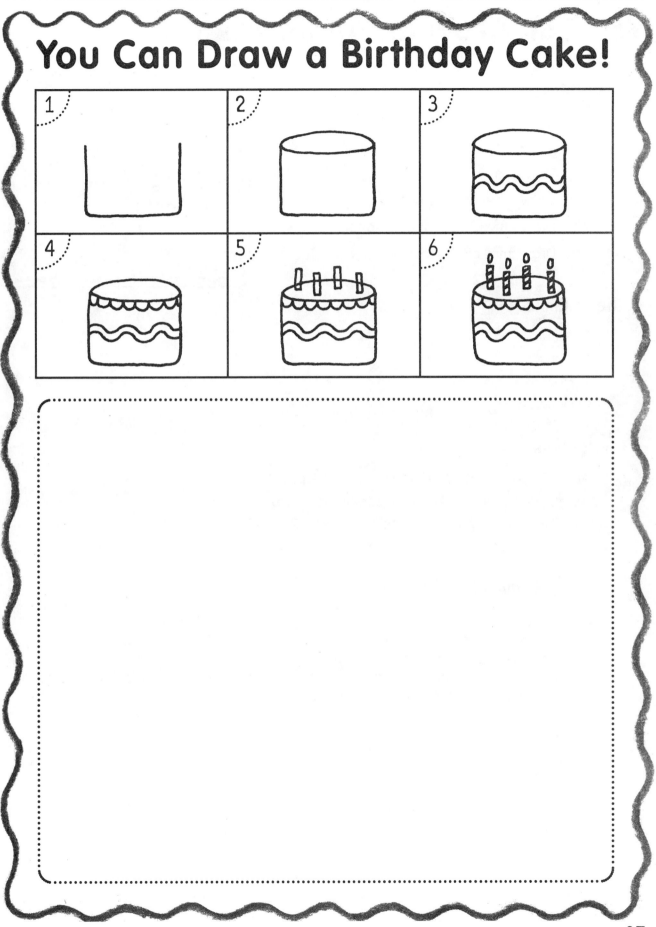

You Can Draw an Apple Tree!

Directions

1. Draw 2 curved lines for the trunk.
2. Draw a curved line in between the trunk.
3. Draw lines for branches.
4. Draw more lines for twigs.
5. Draw curved lines all around for leaves.
6. Draw small circles for apples.

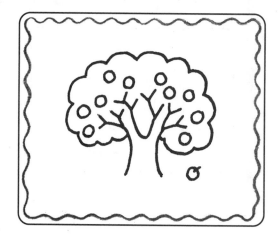

Theme Links

- ☺ Autumn
- ☺ Harvest
- ☺ Fruit
- ☺ Nutrition

Book Links

Apple Tree by Barrie Watts (Silver Burdett Press, 1987)

The Apple Pie Tree by Zoe Hall (Scholastic, 1996)

The Giving Tree by Shel Silverstein (Harper & Row, 1964)

The Seasons of Arnold's Apple Tree by Gail Gibbons (Harcourt Brace Jovanovich, 1984)

Extension Activity

After children have completed their drawings, create a bulletin board display entitled "Our Apple Tree Orchard." Lead a class discussion about the similarities and differences between the trees in each drawing. Create a chart with two columns, and list the similarities and differences that students observe. Show students photographs of apple trees (such as those in *Apple Tree*, above) so that children can find even more similarities and differences.

TEACHER TIP

These drawings look beautiful done in colored pencil. Show students how they can overlap several different shades of brown for the trunk and of green for the leaves.

Name _____ Date _____

You Can Draw an Apple Tree!

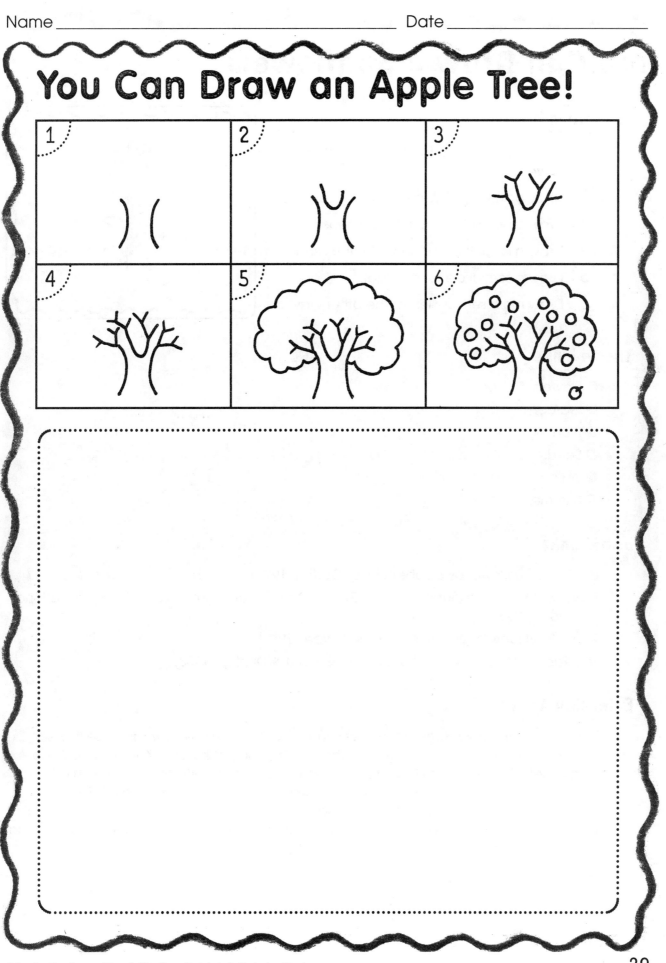

You Can Draw a Sunflower!

Directions

1. Draw a small circle for the center of the flower.
2. Draw pointed petals around the circle.
3. Draw dots inside the circle for seeds.
4. Draw a long, thin rectangle for the stem.
5. Draw a semicircle for one leaf.
6. Draw more semicircles for the other leaves.

Theme Links

☺ Flowers
☺ Gardens
☺ Planting
☺ Seeds
☺ Spring
☺ Summer

Book Links

Backyard Sunflower by Elizabeth King (Dutton, 1993)

Diary of a Sunflower (Super Science Readers) by Carol Pugliano (Scholastic Professional Books, 2000)

Kenny's Window by Maurice Sendak (Harper, 1956)

The Reason for a Flower by Ruth Heller (Grosset & Dunlap, 1983)

Extension Activity

If children have never seen a sunflower, they might not realize how tall these flowers are. Some grow to be 20 feet tall, but the average height is about 6 feet. On a 6-foot-long sheet of craft paper, draw a sunflower in pencil and invite children to color it with paint or crayons. Display the drawing on a wall. Use a tape measure to mark off the measurement by feet and half feet so that children can roughly compare their heights to that of the sunflower. For a more accurate comparison, hang a tape measure beside the sunflower drawing.

You Can Draw a Sunflower!

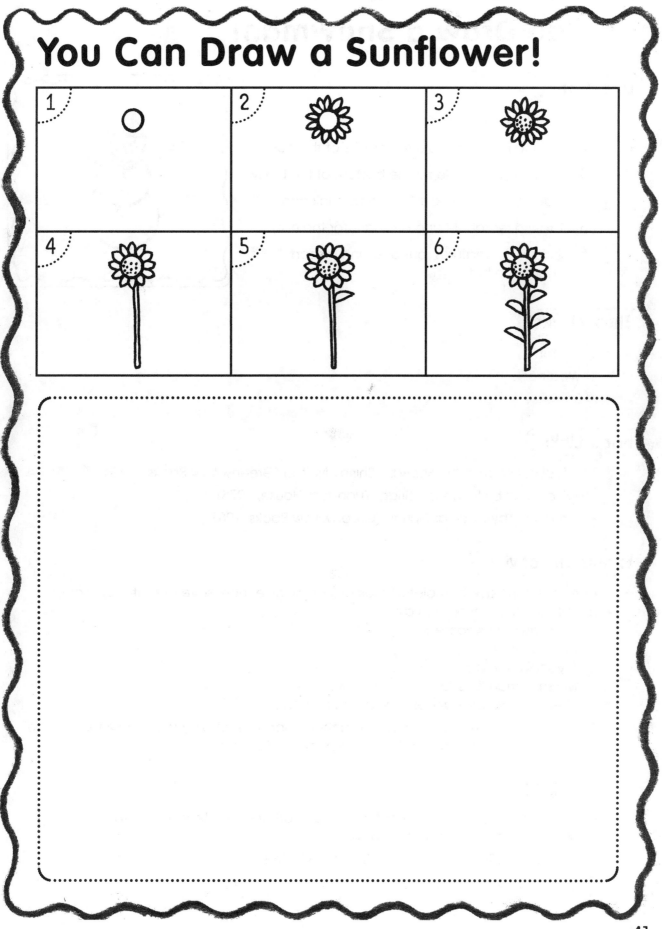

You Can Draw a Snowman!

Directions

1. Draw a small circle for the head.
2. Draw a medium circle for middle of the body.
3. Draw a large circle for the bottom of the body.
4. Add lines to the middle circle for stick arms.
5. Draw a rectangle and a square for the hat.
6. Add facial features, buttons, and a scarf. Shade the hat.

Theme Links

☺ Winter
☺ Weather
☺ Snow

Book Links

The Jacket I Wear in the Snow by Shirley Neitzel (Greenwillow Books, 1989)

The Snowman by Raymond Briggs (Random House, 1978)

A Winter Day by Douglas Florian (Greenwillow Books, 1987)

Extension Activity

After children have completed their drawings, give them several sentence starters about their snowmen, such as:

My snowman's name is…
My snowman…
My snowman can…
My snowman likes to…
These are words that describe my snowman…

After children have written or dictated their responses, display their drawings and their writing or compile them in a "Winter Snowmen" class book.

TEACHER TIP

Write the step-by-step drawing directions on a chart or on sentence strips for a pocket chart. Write additional directions such as:

☺ Draw 6 snowflakes. ☺ Draw 3 buttons.

☺ Color the hat black. ☺ Draw snow on the ground.

You Can Draw a Snowman!

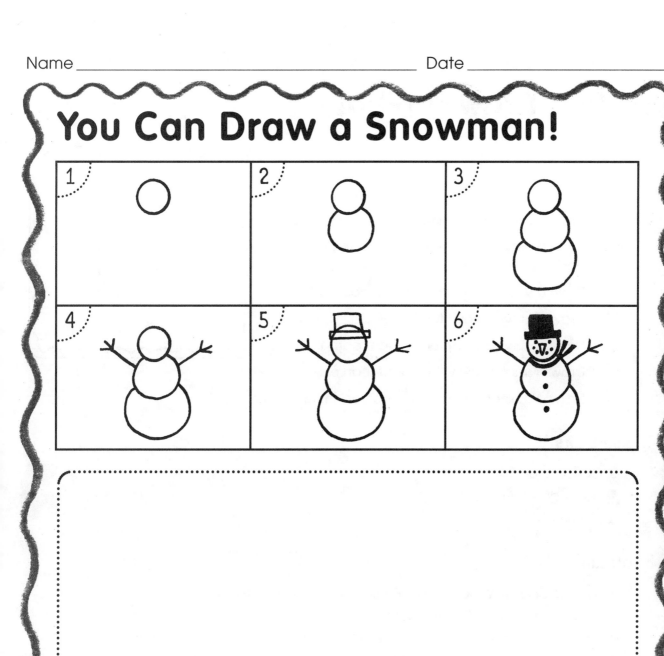

You Can Draw a Whale!

Directions

1. Draw a large curved line for top of the body.
2. Draw a small curved line for the mouth.
3. Draw a curved line for the underside of the body.
4. Draw a small curved line for the base of the tail.
5. Draw a curved point for the left part of the tail.
6. Draw a curved point for the right part of the tail.
7. Draw a small circle with a dot for an eye.
8. Draw a dashed line with two curves on top for the spout.

Theme Links

☺ Ocean Life
☺ Endangered Animals
☺ Mammals

Book Links

Amos and Boris by William Steig (Puffin Books, 1971)

Baby Beluga by Raffi (Crown Publishers, 1990)

Rainbow Fish and the Big Blue Whale by Marcus Pfister (North-South Books, 1998)

Whales by Gail Gibbons (Holiday House, 1991)

Extension Activity

After reading several non-fiction books about whales, have each student write or dictate three facts about whales. Encourage them to add illustrations. Display these whale facts along with children's drawings on a class bulletin board. After displaying students' work, compile the facts and drawings to create a classroom reference book.

TEACHER TIP

The whale drawings look best when they fill large sheets of paper. Distribute 18- by 24-inch (or larger) sheets of white construction paper. Have children first draw in pencil, and then outline with blue crayon. Encourage kids to fill the page as they draw. These drawings look fantastic when a final watercolor wash is added.

You Can Draw a Whale!

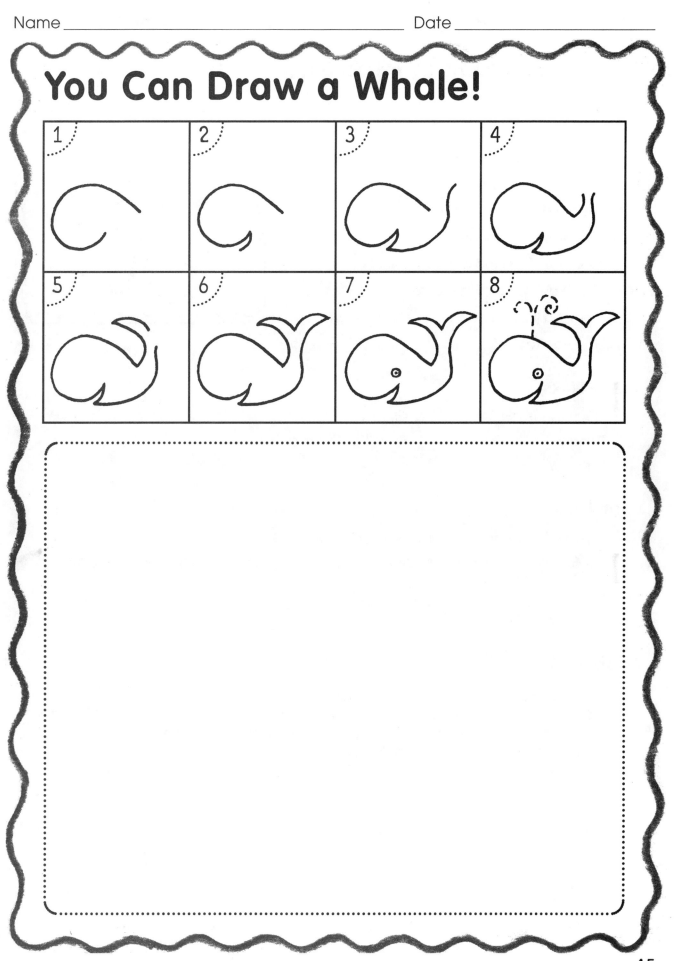

You Can Draw a Person!

Directions

1. Draw a circle for the head.
2. Draw a triangle for the body.
3. Draw 2 rectangles for arms.
4. Draw 2 rectangles for legs.
5. Draw 2 curved lines for hands.
6. Draw 2 small ovals for feet.
7. Add lines for hair.
8. Add facial features.

Theme Links

☺ All About Me
☺ Individuality
☺ Family
☺ Friends
☺ Health and Human Body
☺ Five Senses

Book Links

I Like Me! by Nancy L. Carlson (Viking Kestrel, 1988)

We Are All Alike, We Are All Different by Cheltenham Elementary School Kindergartners (Scholastic, 1991)

You Can't Smell a Flower With Your Ear! All About Your 5 Senses by Joanna Cole (Penguin Putnam Books for Young Readers, 1994)

Extension Activity

After reading aloud books about individuality (see Book Links, above), invite children to draw self-portraits. Provide mirrors and encourage them to look carefully at their facial features, hair color, eye color, and skin tone. When they are finished with their self-portraits, create a classroom display. Later, compile the portraits along with photographs and written pieces in an "All About Us" class book. It's a book they will love to look at all year long!

TEACHER TIP

For their self-portraits in the above extension activity, first have children draw in pencil. Then ask them to outline their drawings in black crayon or colored pencil. Finally, have children use watercolors to complete their portraits.

You Can Draw a Person!

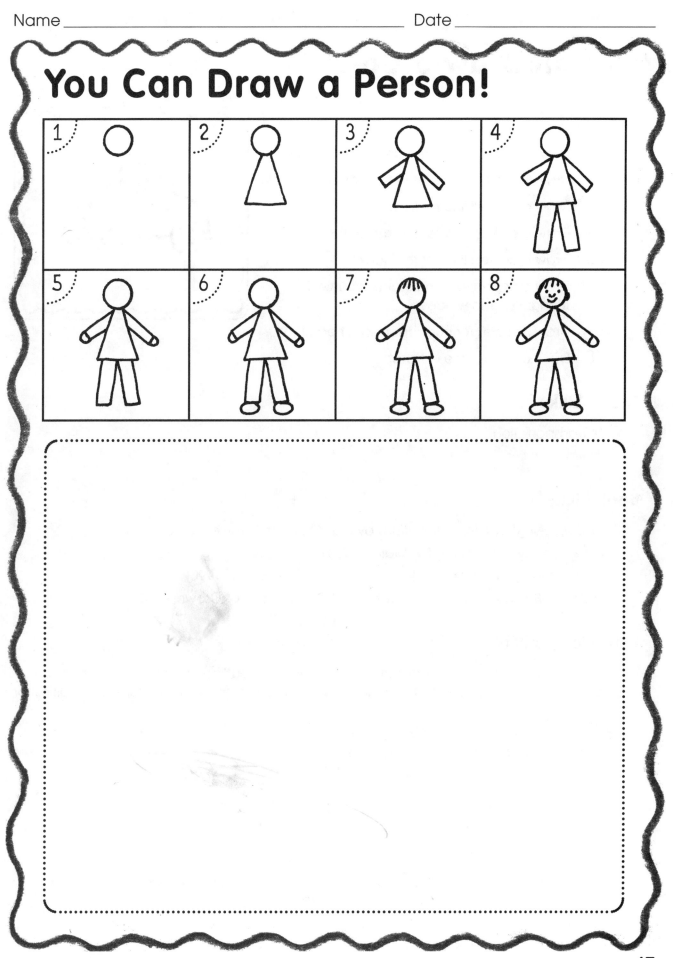

You Can Draw a Car!

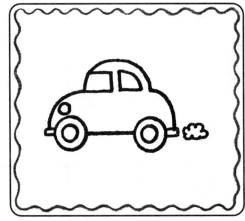

Directions

1. Draw 2 circles with a line connecting them.
2. Draw 2 small rectangles in the front and back.
3. Draw a curved line for the hood.
4. Draw a curved line for the top of the car.
5. Draw a curved line for the trunk.
6. Draw an open rectangle and a curved triangle for the windows
7. Draw 3 circles for hubcaps and a headlight.
8. Draw a puff for the exhaust.

Theme Links

☺ Transportation
☺ Wheels

Book Links

Fill It Up! All About Service Stations by Gail Gibbons (Crowell, 1985)

Little Auto by Lois Lenski (H. Z. Walck, 1934)

On the Go by Ann Morris (Lothrop, Lee & Shepard Books, 1990)

Traffic: A Book of Opposites by Betsy and Giulio Maestro (Crown, 1981)

Extension Activity

Have students write poems about their car. Write this outline on the chalkboard or on chart paper as a guide, and provide an example. As a group, brainstorm possibilities for each line.

	For example:
Size and color	Big and red
Speed	Quick as lightning
Location	On the highway
Destination	I'm going to town!

TEACHER TIP

Display students' poems and illustrations on a clothesline draped across the classroom. Students can also draw other types of vehicles and write poems about them to add to the display.

You Can Draw a Car!

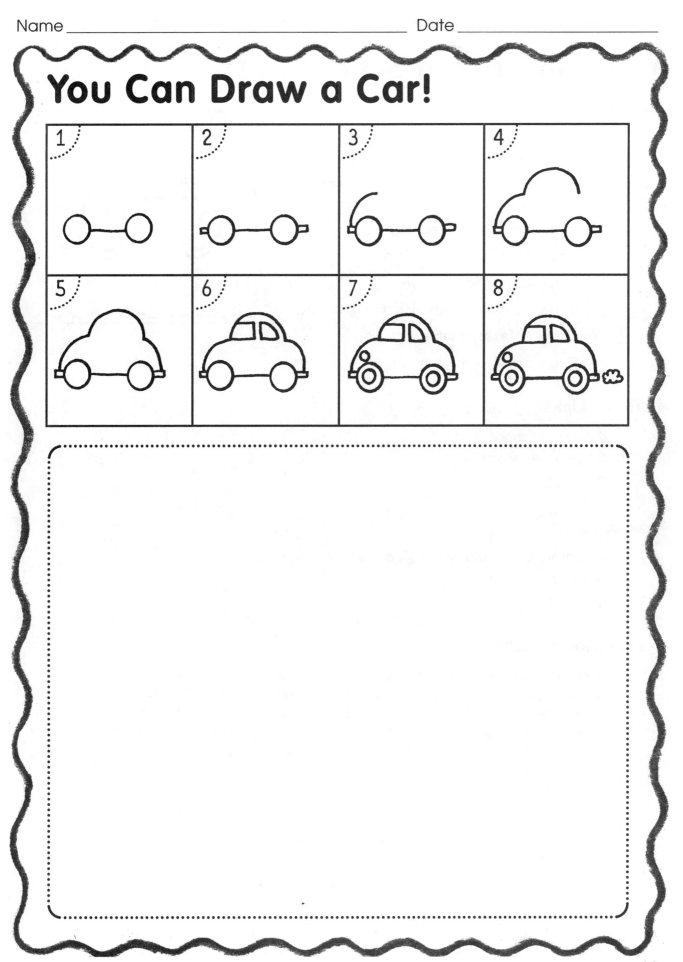

You Can Draw a School Bus!

Directions

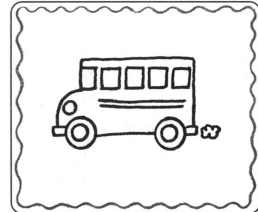

1. Draw 2 circles and a line connecting them.
2. Draw 2 small rectangles in the front and back.
3. Draw a large open rectangle.
4. Draw a curved line in the front.
5. Draw squares for windows.
6. Draw 3 circles for hubcaps and a headlight.
7. Draw 2 lines for a stripe.
8. Draw a puff for the exhaust.

Theme Links

☺ Back to School
☺ Transportation
☺ Wheels

Book Links

School Bus by Donald Crews (Greenwillow, 1984)

Wheels by Byron Barton (Crowell, 1979)

Wheels on the Bus by Raffi (Crown, 1998)

Extension Activity

Make a class mural of an extra-long bus with a window for each student in your class. First draw an outline of the bus in pencil on a long sheet of craft paper. Then invite students each to draw a picture of themselves in one window of the bus and write their name below their picture. Children can color the bus with paint or crayons and add a road, trees, and buildings in the background. Display the mural and title it "_____'s class is on the go!"

TEACHER TIP

The extension activity works well as a back-to-school class project. It can also be done before or after a class trip on a school bus.

Name _____ Date _____

You Can Draw a School Bus!

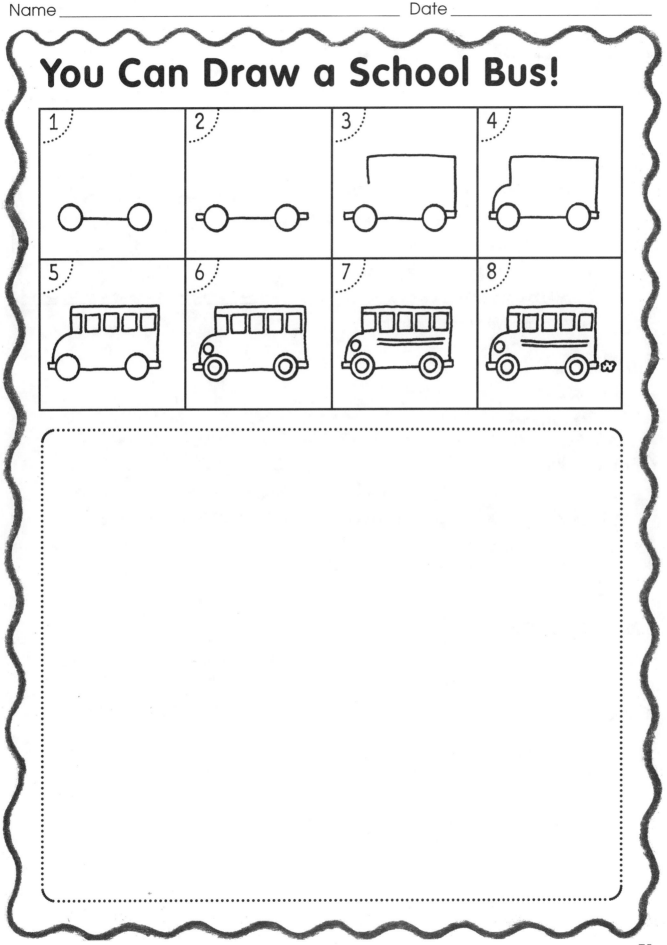

You Can Draw a Frog!

Directions

1. Draw an oval for the body.
2. Draw 2 circles for the eyes.
3. Draw 2 curved lines for the back legs.
4. Draw 2 pointed ovals for the back feet.
5. Draw 4 lines for the front legs.
6. Draw pointed shapes for the toes.
7. Add a dot inside each eye.
8. Add a curved line for a smile.

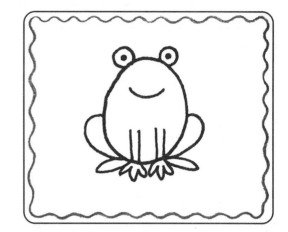

Theme Links

☺ Pond Life
☺ Amphibians

Book Links

The Frog Alphabet Book by Jerry Pallotta (Charlesbridge, 1990)

Froggy Gets Dressed by Jonathan London (Viking Press, 1992)

Jump, Frog, Jump! by Robert Kalan (Greenwillow Books, 1981)

Red-Eyed Tree Frog by Joy Cowley (Scholastic Press, 1999)

Tuesday by David Wiesner (Clarion Books, 1991)

Extension Activity

Create a bulletin board display of a class pond with students' cutout illustrations. Add lily pads and plants cut out from craft paper or felt. Add other student drawings as well, such as turtles, fish, and plants.

TEACHER TIP

Frogs come in a variety of colors in addition to green, including blue, yellow, red, and orange. Show children photographs or illustrations of colorful frogs, such as different varieties of poison dart frogs. Explain that the bright colors warn predators not to eat them. After showing the pictures, encourage kids to use brightly colored paints and crayons to color their frog drawings. These fit in nicely with a rain forest mural.

Name _____ Date _____

You Can Draw a Frog!

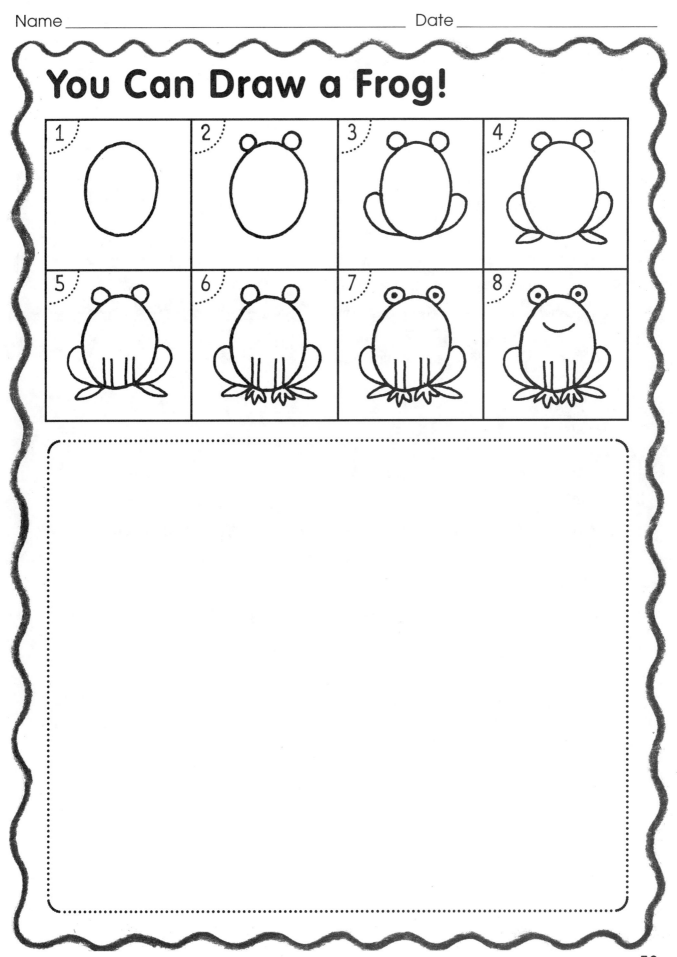

You Can Draw a Dog!

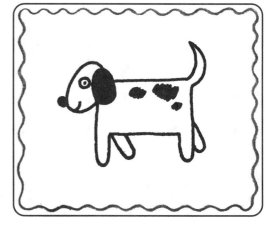

Directions

1. Draw an oval for the head.
2. Draw a line for the back.
3. Draw a curved, pointed tail.
4. Draw 2 curved lines for the legs.
5. Draw a line connecting the legs.
6. Draw 2 curved lines for the other legs.
7. Draw an oval for an ear and a circle for the nose.
8. Add facial features and spots. Shade the ear and nose.

Theme Links

☺ Pets
☺ Friendship

Book Links

The Adventures of Taxi Dog by Debra and Sal Barracca (Dial Books for Young Readers, 1990)

Clifford the Big Red Dog by Norman Bridwell (Scholastic, 1985) and other books in the Clifford series

Good Dog, Carl by Alexandra Day (Green Tiger Press, 1985) and other books in the Carl series

Extension Activity

Show children photographs or illustrations of different kinds of dogs. Draw a two-column chart on the chalkboard or on chart paper and ask them to note the similarities and differences. For example, they might say for similarities that dogs have tails, four legs, fur, teeth, and so on. Differences can include size, shape of body, shape of ears, and color of fur.

TEACHER TIP

Invite children to choose their favorite kind of dog and write or dictate a short, descriptive poem about it. Then have children add an illustration of their favorite kind of dog.

Name _____ Date _____

You Can Draw a Dog!

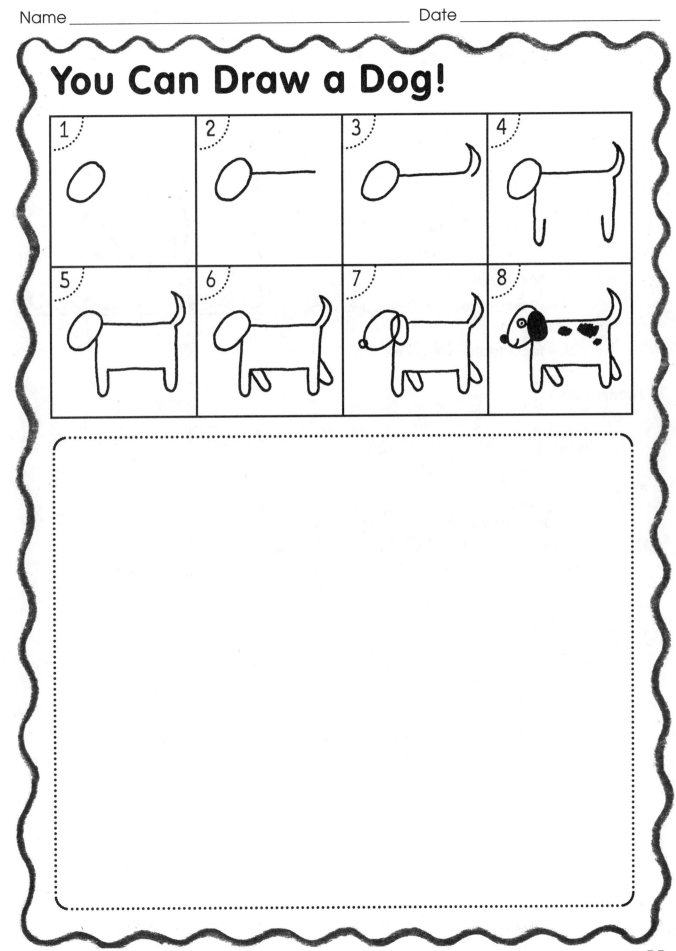

You Can Draw a Cat!

Directions

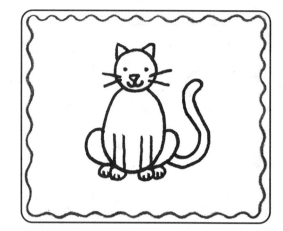

1. Draw a circle for the head.
2. Draw 2 triangles for ears.
3. Draw an oval for the body.
4. Draw 2 curved lines for the back legs.
5. Draw 4 lines for the front legs.
6. Draw 4 circles for the paws.
7. Draw 2 curved lines for the tail and small lines for toes.
8. Add facial features and whiskers.

Theme Links

☺ Pets
☺ Friendship

Book Links

Cross-Country Cat by Mary Calhoun (Morrow, 1979)

Feathers for Lunch by Lois Ehlert (Harcourt Brace Jovanovich, 1990)

Rotten Ralph by Jack Gantos (Houghton Mifflin, 1976) and other books in the Rotten Ralph series

Extension Activity

After reading one of the books in the Rotten Ralph series (see Book Links), give students the following sentence starters:

Rotten Ralph was bad when...
Rotten Ralph was good when...

Have students write or dictate their responses and then add illustrations.

TEACHER TIP

On chart paper, make a bar graph of students' favorite animals and tally the results.

Name _____ Date _____

You Can Draw a Cat!

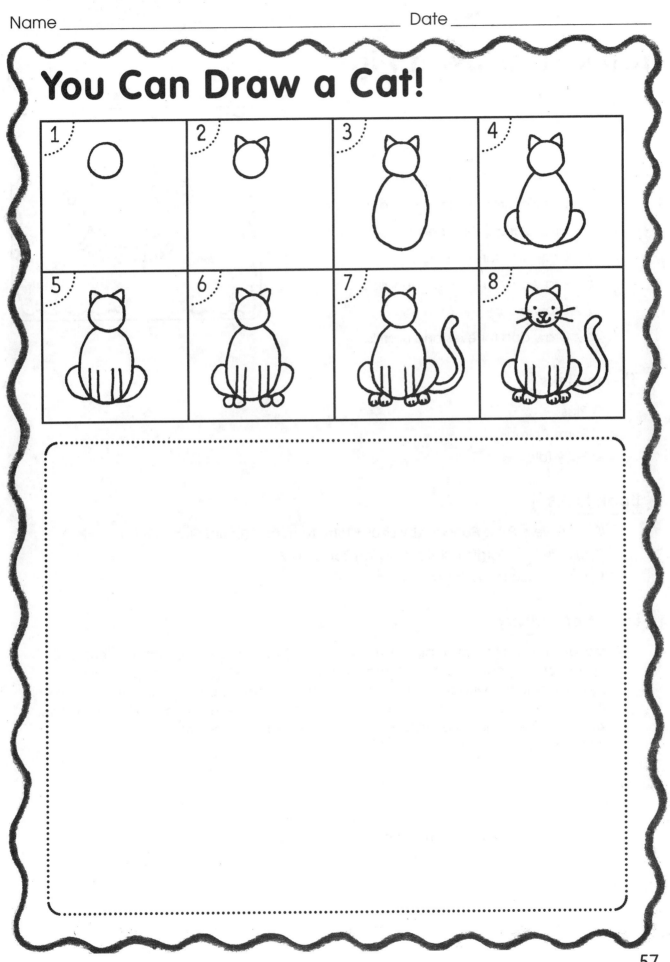

You Can Draw a Pig!

Directions

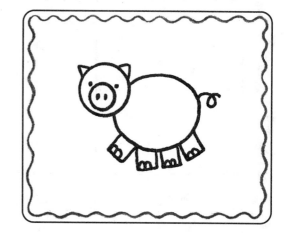

1. Draw a circle for the head.
2. Draw a small circle inside for the snout.
3. Draw a large oval for the body.
4. Draw 2 triangles for ears.
5. Draw 4 squares for legs.
6. Draw curved lines for toenails.
7. Draw a curly line for a tail.
8. Draw dots for eyes and nostrils.

Theme Links

☺ Pigs
☺ Farm Animals
☺ Fairy Tales

Book Links

If You Give a Pig a Pancake by Laura Joffe Numeroff (Laura Geringer Book, 1998)

Piggie Pie! by Margie Palatini (Clarion Books, 1995)

Pigs by Robert Munsch (Annick Press, 1989)

Extension Activity

Make a large, interactive pig puzzle with felt or posterboard. Cut out different-sized circles for the head, snout, and body. Then cut out two triangles for ears and four squares for legs. Invite students to put the puzzle together by arranging the pieces on the floor or on a table, or attaching the pieces to a bulletin board or felt board. After kids have assembled the body, they can use reusable adhesive gum to attach movable eyes and a piece of pink yarn for the tail.

TEACHER TIP

Write the step-by-step directions on a chart or on sentence strips. Place the directions beside the puzzle, and set them up in a classroom literacy center.

You Can Draw a Pig!

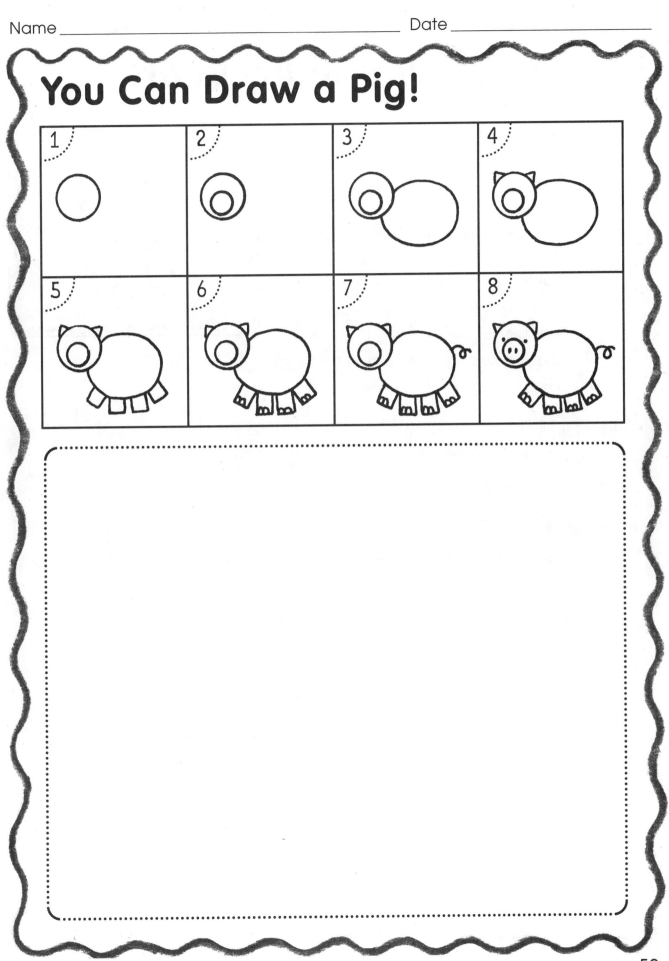

You Can Draw a Teddy Bear!

Directions

1. Draw a circle for the head.
2. Inside the circle, draw a smaller circle for the snout.
3. For each ear, draw a small semicircle inside another semicircle.
4. Draw a large oval for the body.
5. Draw 4 ovals for the legs.
6. Draw lines for toes.
7. Inside the body, draw a circle for the tummy.
8. Draw a nose, mouth, and eyes.

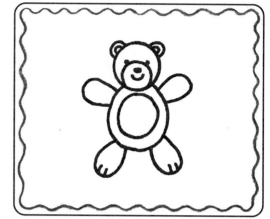

Theme Links

☺ Bears
☺ Friendship

Book Links

Corduroy by Don Freeman (Viking Press, 1968) and other books in the Corduroy series

Good Night, Baby Bear by Frank Asch (Harcourt Brace, 1998) and other books in the Bear series

Ira Sleeps Over by Bernard Waber (Houghton Mifflin, 1972)

Extension Activity

Host a teddy bear party! Invite students to bring their favorite teddy bear or other stuffed animal to school. Encourage students to introduce their animals to each other and tell one or two facts about their toy. Have kids set out pillows and sleeping bags for a slumber party for their stuffed animals.

TEACHER TIP

Have kids write or dictate a short story or poem about their teddy bear or other stuffed animal. Determine a bedtime for the slumber party and have kids share what they wrote as bedtime stories. Kids can read to small groups of their classmates and their stuffed animals.

Follow the Directions and Draw It All by Yourself! Scholastic Professional Books

You Can Draw a Teddy Bear!

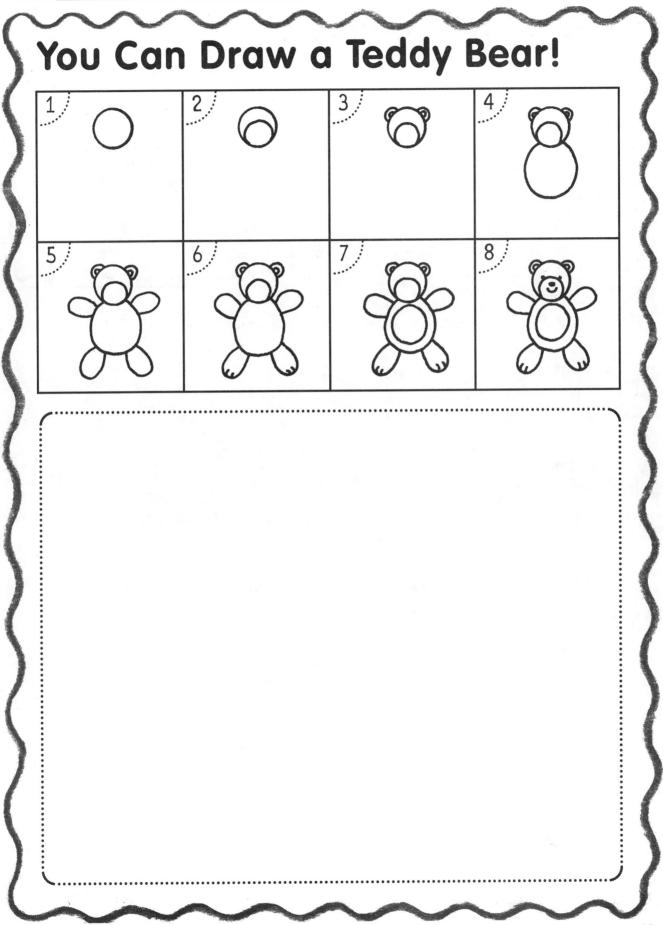

You Can Draw a Turkey!

Directions

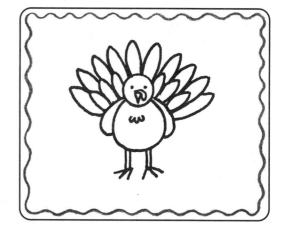

1. Draw a small circle for the head.
2. Draw a large circle for the body.
3. Draw 2 curved lines for wings.
4. Draw 2 thin rectangles for legs.
5. Draw lines for toes.
6. Draw tall ovals for the first row of feathers.
7. Add more ovals for the second row of feathers.
8. Add facial features and small feathers on the chest.

Theme Links

☺ Thanksgiving
☺ Farm Animals

Book Links

It's Thanksgiving, poems by Jack Prelutsky (Greenwillow Books, 1982)

Gracias, the Thanksgiving Turkey by Joy Cowley (Scholastic Press, 1996)

A Turkey for Thanksgiving by Eve Bunting (Clarion Books, 1991)

Turkey on the Loose by Sylvie Wickstrom (Dial Books for Young Readers, 1990)

'Twas the Night Before Thanksgiving by Dav Pilkey (Orchard Books, 1990)

Extension Activity

Invite students to write or dictate a story about their turkey. Compile the drawings and stories in a class Thanksgiving book. Add other student work about Thanksgiving, such as poems, stories, and illustrations of what children are thankful for.

TEACHER TIP

Visit the following Web sites for lots of information about Thanksgiving topics:

Plimoth Plantation (www.plimoth.org)

Pilgrim Hall Museum (www.pilgrimhall.org)

John Alden House (www.alden.org)

The Wamanoag: People of the First Light, The Boston Children's Museum (www.bostonkids.org)

Follow the Directions and Draw It All by Yourself! Scholastic Professional Books

Name _____ Date _____

You Can Draw a Turkey!

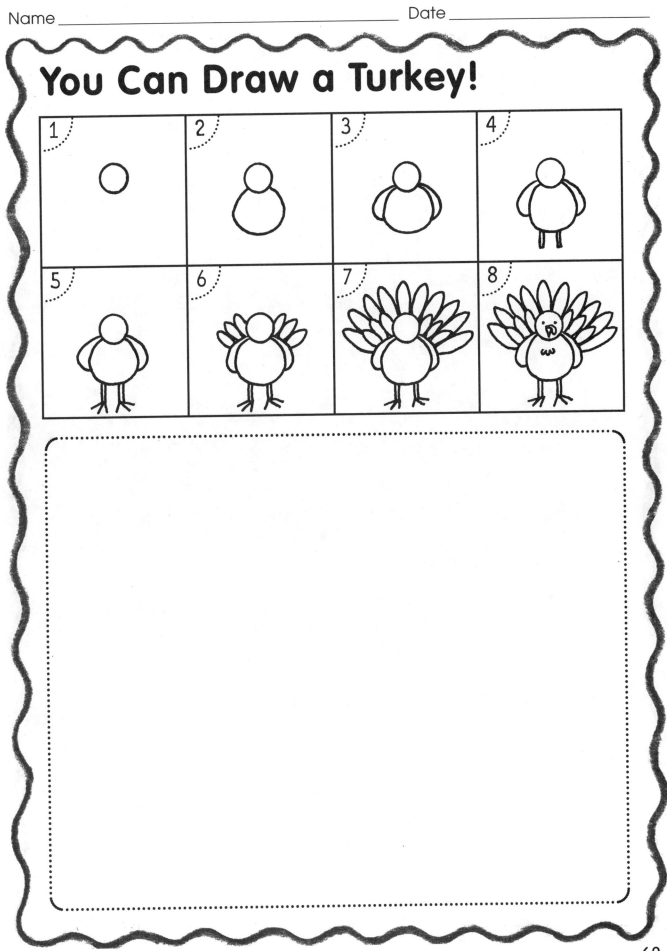

Follow the Directions and Draw It All by Yourself! Scholastic Professional Books

63

Name _____ Date _____

You Can Draw a _____ !

1	2	3	4
5	6	7	8

Follow the Directions and Draw It All by Yourself! Scholastic Professional Books